The
CHRISTMAS
STORY

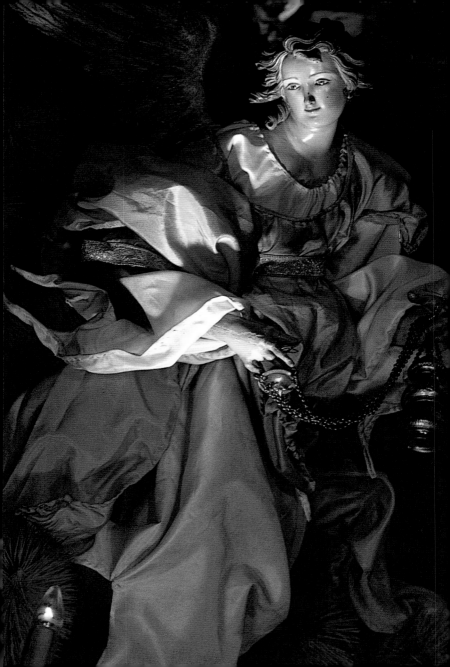

CHRISTMAS STORY

TEXT SELECTED BY

LINN HOWARD AND

MARY JANE POOL

PHOTOGRAPHS BY

ELLIOTT ERWITT

HARRY N. ABRAMS, INC., PUBLISHERS

HE CHRISTMAS story is illustrated here with eighteenth-century Neapolitan crèche figures from the renowned Loretta Hines Howard collection at The Metropolitan Museum of Art in New York. ❋ Leading artists of the kingdom of Naples sculpted the heads of the figures in terra cotta. The flexible figures, which stand no more than twenty inches high, are fashioned of tow, wire, and carved wood.

Imitating the fashions of their own day, the Neapolitans dressed the figures in the home-spuns and embroideries of their townspeople and the shimmering silks and jewels of their kings and queens. The animals that surround the manger are sculpted in wood. ❈ The exhibition of this splendid crèche at the Metropolitan Museum each Christmas season is a joyous reminder of the Nativity, and a celebration of faith and family.

. . . the angel Gabriel was
sent from God unto a city of
Galilee, named Nazareth,
To a virgin espoused to a man
whose name was Joseph,
of the house of David; and the
virgin's name was Mary.

Luke 1:26, 27

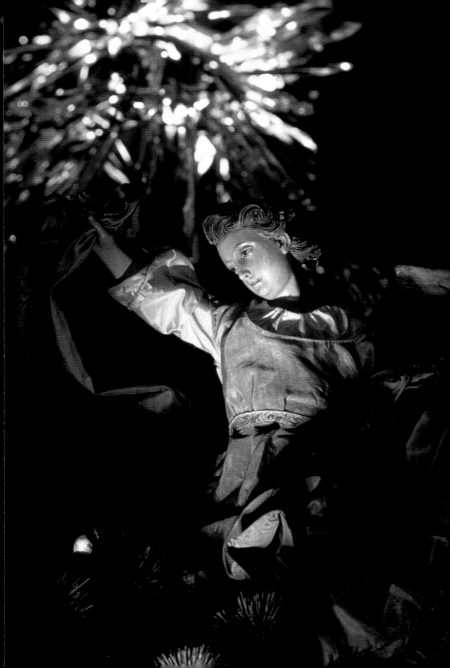

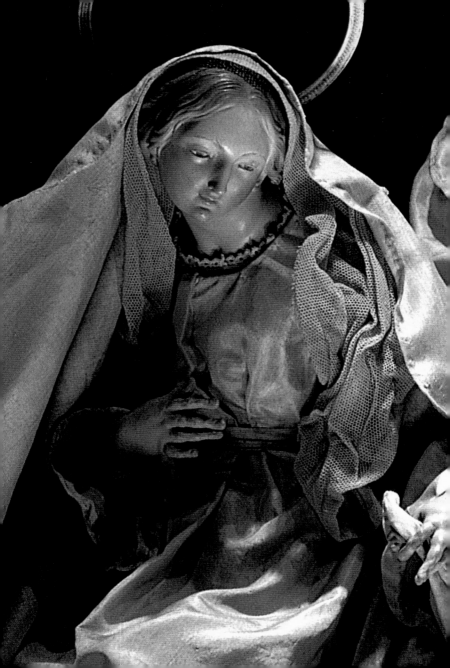

And the angel said unto her,

Fear not, Mary; for thou hast

found favour with God.

And, behold, thou shalt conceive

in thy womb, and bring forth a son,

and shalt call his name JESUS.

He shall be great, and shall be called

the Son of the Highest . . . and

of his kingdom there shall be no end.

Luke 1:30–33

And it came to pass in those
days, that there went out a decree
from Caesar Augustus, that all
the world should be taxed.
And all went to be taxed, every
one into his own city.
And Joseph also went up from
Galilee . . . unto the city of David,
which is called Bethlehem . . .
To be taxed with Mary his espoused
wife, being great with child.

Luke 2:1, 3–5

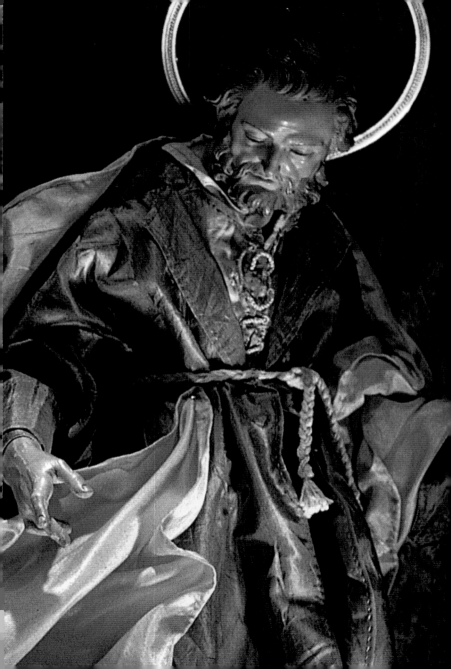

And so it was, that, while they
were there, the days were accom-
plished that she should be delivered.
And she brought forth her
firstborn son, and wrapped him
in swaddling clothes, and laid him
in a manger; because there was
no room for them in the inn.

Luke 2:6, 7

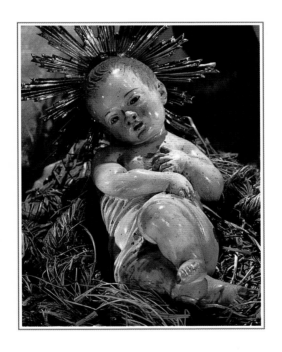

And there were in the
same country shepherds abiding
in the field, keeping watch
over their flock by night.
And, lo, the angel of the Lord
came upon them, and the glory of
the Lord shone round about them:
and they were sore afraid.

Luke 2:8, 9

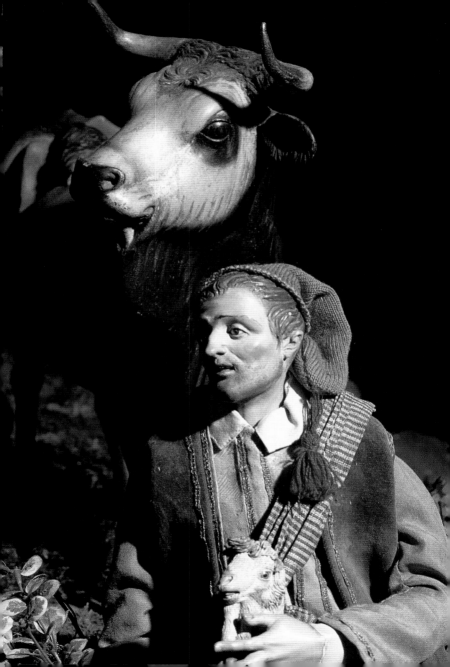

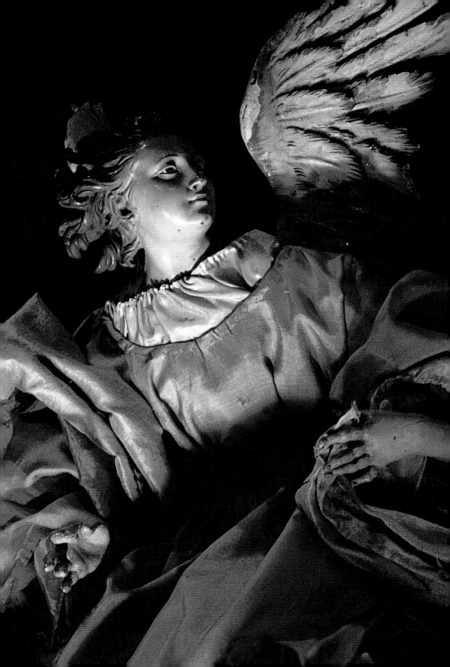

And the angel said unto
them, Fear not: for, behold,
I bring you good tidings of great
joy, which shall be to all people.
For unto you is born this day
in the city of David a Saviour,
which is Christ the Lord.
And this shall be a sign unto you;
Ye shall find the babe wrapped in
swaddling clothes, lying in a manger.

Luke 2:10–12

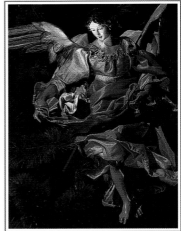

And suddenly there was with the angel a multitude

of the heavenly host praising God, and saying,

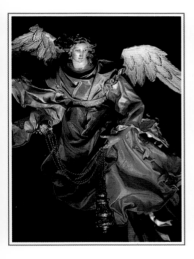
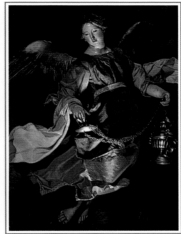

Glory to God in the highest, and on earth

peace, good will toward men. *Luke 2:13, 14*

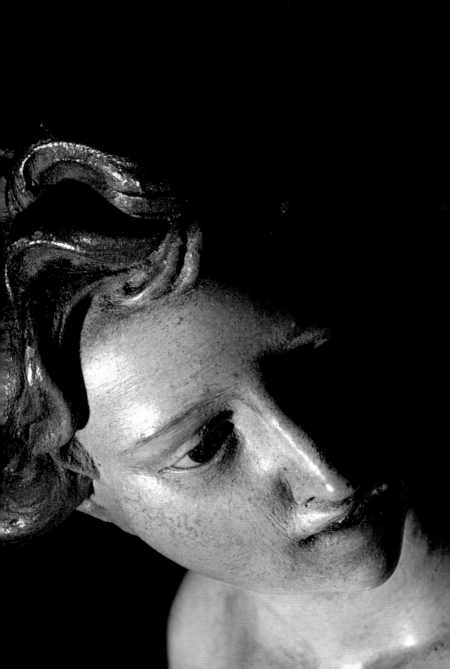

And it came to pass, as the
angels were gone away from them
into heaven, the shepherds said
one to another, Let us now go even
unto Bethlehem, and see this thing
which is come to pass, which
the Lord hath made known unto us.
And they came with haste,
and found Mary, and Joseph,
and the babe lying in a manger.

Luke 2:15, 16

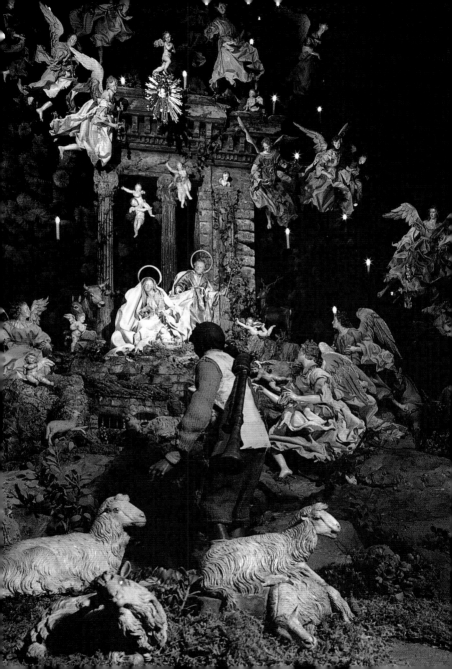

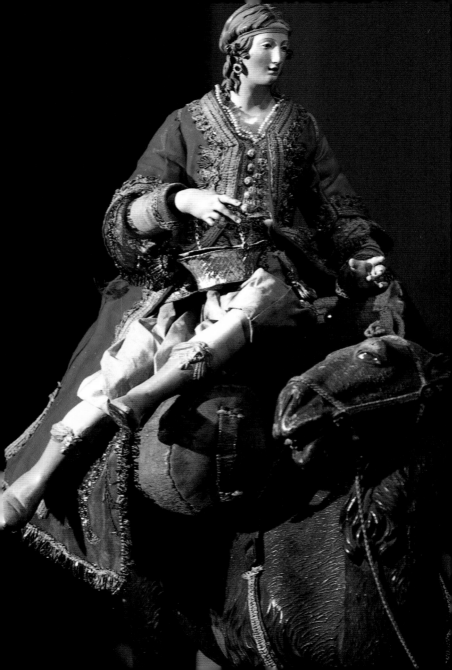

And when they had seen it, they made
known abroad the saying which was told them
concerning this child. And all they that heard
it wondered at those things which were told
them by the shepherds . . . And the shepherds
returned, glorifying and praising God for all
the things that they had heard and seen . . .

Luke 2:17, 18, 20

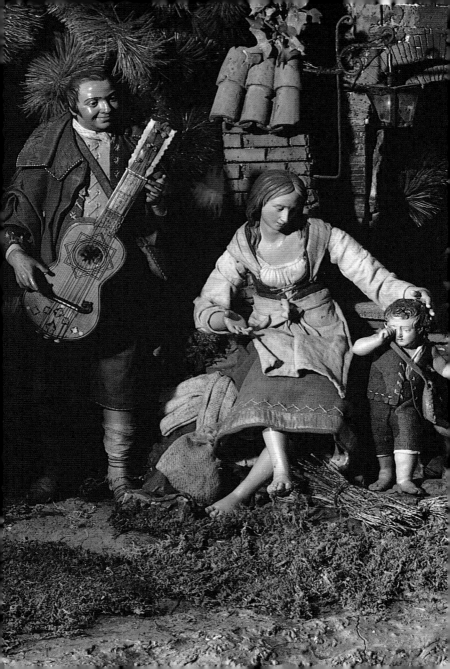

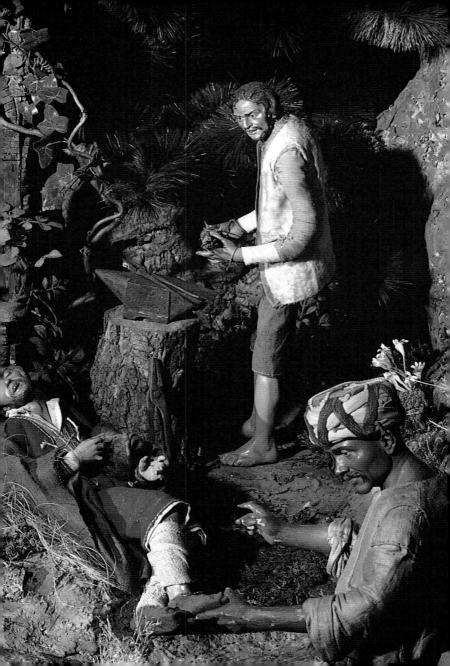

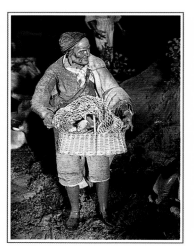
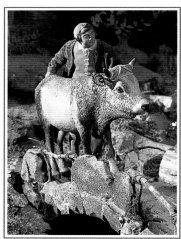

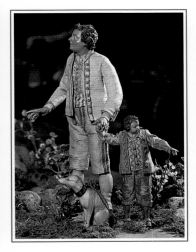

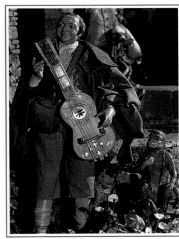

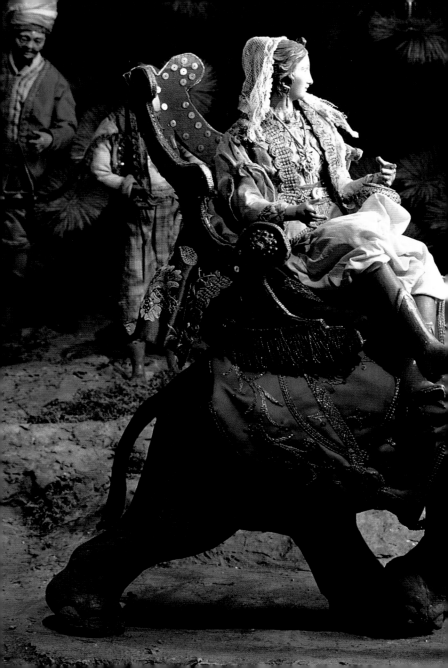

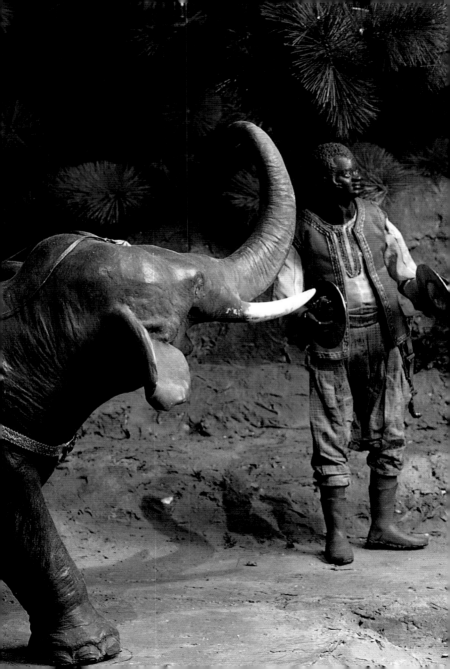

. . . behold, there came wise men
from the east . . . Saying, Where
is he that is born King of the Jews?
for we have seen his star in the east,
and are come to worship him.
. . . and, lo, the star, which
they saw in the east, went before
them, till it came and stood over
where the young child was.

Matthew 2:1, 2, 9

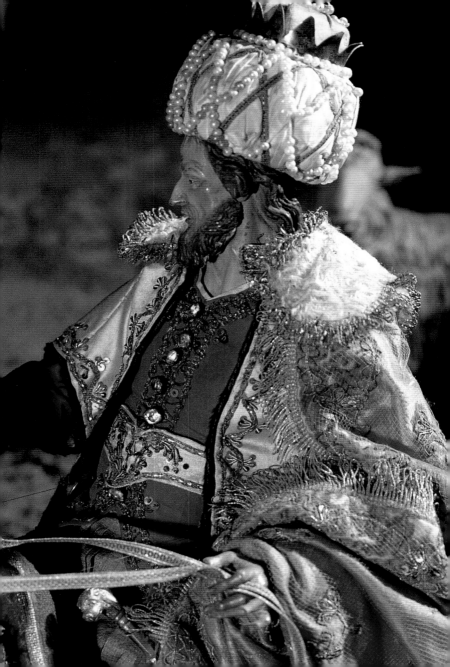

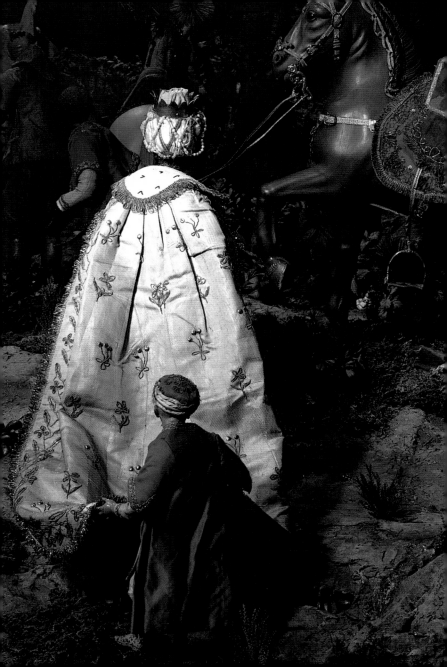

When they saw the star, they rejoiced
with exceeding great joy. And when they
were come into the house, they saw the young
child with Mary his mother, and fell down,
and worshipped him: and when they had
opened their treasures, they presented unto him
gifts; gold, and frankincense, and myrrh.

Matthew 2:10, 11

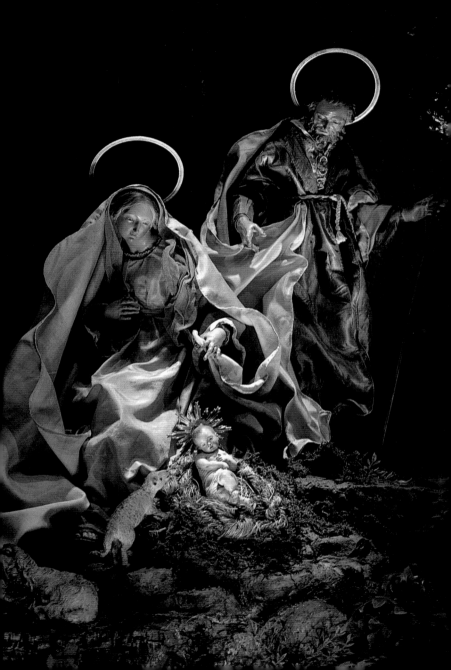

For unto us a child is
born, unto us a son is given:
and the government shall be upon
his shoulder: and his name
shall be called wonderful . . .
The Prince of Peace.

Isaiah 9:6

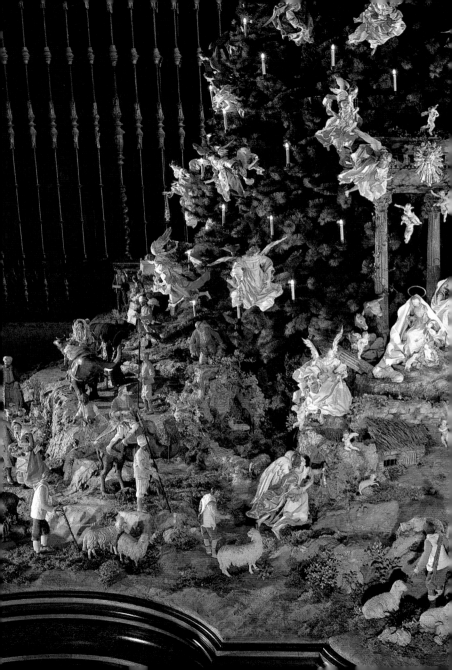

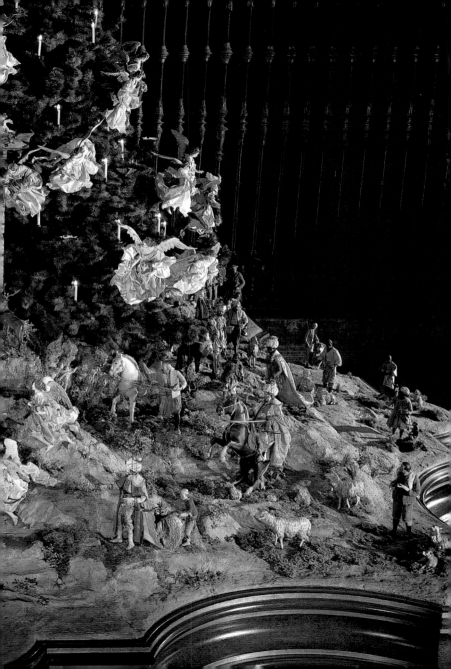

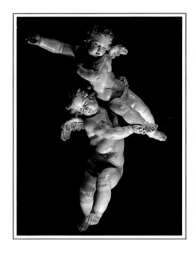

Project Director: MARGARET L. KAPLAN

Designer: MARY JANE CALLISTER

All Biblical quotations are from the King James Version

Library of Congress Control Number: 2001090954

ISBN 0-8109-1197-3

10 9 8 7 6 5 4 3 2 1

HARRY N. ABRAMS, INC.

100 Fifth Avenue, New York, N.Y. 10011

www.Abramsbooks.com